My Heart longs to be heard

GW00384657

Leanne Drain

BookLeaf
Publishing

My Heart longs to be heard © 2022 Leanne Drain

Presentation by *BookLeaf Publishing*

Web: www.bookleafpub.com

E-mail: info@bookleafpub.com

ISBN:

First edition 2022

A Ballard of our world

There is something about the movements of the
wind, catching breaths from a beautiful view.
Oh, how the sun has glorious ways of reaching
out to the world.
The world has hands as mighty as lambs and
strong as lands.
The hands comfort the world, nurturing it into a
blooming flower from the seed.
Radiant and almost rare by its fancy colours that
gleam.
What if we could live in this beautiful world and
replace this life with light instead of the constant
darkness that dies out in the night.
For the world is bleak and has no love to speak.
The world has crowds; they gather like darkness
with no name; it is forever gone by humanity
and incarnated with flames; watching them
become ashes is such a shame.
The world hopes to be brighter but is
permanently infuriated by the storm, not just by
the disastrous winds but by the people.
Unfortunately, the people control this world.
Alas, I would love to live inside a house that is
full of love, warmth, and hope.

Why can't we have a world like that, full of beautiful times ahead? The moon once spoke to the world in tongues seeking its hands to justice its warmth.

There is something about the light of the world, how it catches the stars, how it speaks to us.

I believe the world has become our friend once more thy flower, thee shower, thee one from an hour may gloss in gold forever behold in the telling tale of this broken immunity.

A story of the world being loved and sold.

A sonnet to Death

1)Engulfed by the sound of death, pain at every corner

2)From the burner of light, flickering out of control

3)There is no matter of the home, no way out

4)Only rain that goes fluidly down the drain(staining)

5) Pain touching the embroidery around the glossy bound table

6)A sound, waiting in the wings be found.

7)Silently, she takes her last breath, gasping air

8) breaking out with care, she dares to stare

9) The battle of thoughts vs. bleakness deathly hallowing gone.

10)Leaving marks that no one can see, ghastly figures

11) dying, crying in her skin, leaning forward

12)protected by the reign of God, calling her

13)She believes in his presence, although there are crescents

14)clashing out golden, stains of pain, death waiting always.

What My nan said (Free verse)

I have noticed how women in their eighties,
How they speak in tones of vividness, how they
touch the world with their smile
I see it now, a woman approaching eighty, sitting
back telling stories of the good old days.
How they were golden and ripe, telling the
grandchildren of dancing on bars and listening to
the wars that happened years ago.
I see it now, an old chair rocking back and forth
in the garland wind. Catching breaths of
escaping reality.
She smiled at me, the lady in the chair you have
much ahead of you. Let us hope you use your
time wisely as I did. Having children is not your
future; your future is you; make sure you live it
fully.
You worth more than any diamond in the sky,
and ring a man gives do not take it, examine it
with your heart and make sure a keeper.

A haiku to a new life

You Grew in my stomach,
Listened to your heartbeat
Welcoming you into the world.

Boarding the Train

So what? I touch my bag to protect it from the lonely walkers.

So what? I place my oyster card in the silver machine, and it almost falls out of my grip.

So what? I board the train and have no direction to where I am going.

So what, I am traveling alone in this world.

So what? I look out the shimmering windows to see the beautiful view.

So what, I watch the people pass by in the carriage.

So what? I see the houses, the farms, the hills as I zoom past the train tracks.

So what? I listen to the lady's voice addressing the next stop.

So what? This journey is almost over.

So what, I hear my thoughts hitting out against my brain; some are my friend, and some are not.

So what? I am alert to hear the train flying through the wind most of the time.

So what? I am no longer afraid to travel.

So what, the air is filtered with the windows open.

So what? I am two steps away from west ham.

So what? It is my time to get off, and I believe it will be a good day.

Mental Health a Narrative poem

This is real. This is happening. The world has stopped again for seconds
It has stopped and come to a still, listen can you hear the pain that goes through another life
The trembled hands of a soul that has endowered the anxious reality of life.
A sound always starts with a radiant and brightly coloured sound, but this is more darkness than light. The sound is voiced, constantly hitting against the head of another lonely gem.
Time and time again, I hear it come on the news another life lost, another time pushed aside like numbers in tribes.
I can't imagine the infuriation that goes on; in their lonely eyes, their families' loss is devasting, and it is not getting any better.
The world seems to caster out people that have mental health
You can't put a plaster on something you cannot see.
Sickening, to the death of the democracy, the crying out the weeping fate of those who lose again.
I can't bear it all, this suffering, this pain.

I feel as if the world has lost its marbles, for how can someone be without love.
Without care, I wish to death that there was some way out of this mess.
I confess that the world is brighter than any star shone lighter but let us pray for those who are no longer with us.
But let us change the way we are toward people. Be kind; let them speak.
We all need to live in a world full of hope rather than pain.

Going to Oxford

I see people going to oxford, walking around in
a dream light state.
How they hold their head high, among the fairies
from the skies.
They listen, speak, and reach,
but above all, their glorious heads are of
flamboyant nature.
How they structure their day, accordingly
without play
Their dreams are stated there red and gold.
I see it now a stage full of dreamers making their
way among the
seamless roads of life.
How they try to become friends with one
another, I am lost by their
sociality, how they cling together like animals in
a nest.
Oh, how life has changed, I see people going to
oxford, but I am glad
it's not me.

Parameter iambic

Time itself stopped again.
I have lost the time, and it has gone.
I have seen the sky. It is open, heavenly delight,
and brightly devoured
I am again once with the light.
I am again once with the light, soon to be gone,
with time
I have swallowed the time capsule, the watch
from the wrist of a man.
It is gone, the time never to be seen again.
I have stopped, like a stop sign waiting at the
crossroads
Is it time itself that happens to be defeated?
Inside the world, there is a veil. Open it, let there
be light.
But listen to the time, as it ticks inside me, the
capsule of death has gone again.

Angels are real

Angles are actual, living among us
Tears fall from an angel's face,
The creature in white smiles at the tears,
Happily, radiant, and gaily.
The tears of happiness, of forgiveness from the
light, fall beneath the
truth.
Her truth, be free from heavens alluring doors.
She is an angel from another life, a once human
that walked the
earth, waiting, silently in the balcony, for an
empty window
opportunity to arise to leave heaven and finally
be free from heavens lonely world

crispy winter a Haiku

It freezing, cold-hearted running
Winter leaves unfolding.

Musical instruments of the nightly roots that grow below

The chill, fresh in glass
As the trumpets below play on.

Darkness a Haiku

The darkness grew, a ghastly figure.
I was floating towards a graveyard.
Home at last.

No one goes out without there coat on

It is cold; I am shaking, frightened
Leaving my coat on.

Falcon the bird rhyming poem/ rap

Falcon was his name; eating seeds was his game
How he loved to claw his way through anything
Juices of pride came out in tides. He was full of
eating seeds
Bloated with snide, he came out looking like the
master
Of shine. Please don't mess with a falcon. He
will have your head off
In a mountain.
But please don't drink the fountain where he
lays.

Anxious Minds

I feel it pulsing throughout my body; the world
is dark; there is no light.
Its thoughts are grey like the smoke in lungs
escaping to breathe; I feel myself drowning in its
fluid; the fixture of this is I'm letting it win; it
controls my every move. I see it, hear it, and am
it unfolding memories of the past turn to pain. I
know I am a death door away from this anxiety.
I listen to my body, and my hands sweat my
heart races. I am letting it destroy me; as it
comes into force, I see a man on a horse
metaphorically. He is lost like me, trying to find
his way to be freed. He wants to be home like
me. I relate anxiety and compress the eternal
nature of this pain.
Physiological I am lost, but the light is near, and
in a person, I steer my heart back to the world of
light again.

Shell out of the sea
alliterative poem

The pain is excruciating
How I try to break out of this shell
A shell that has no backbone.
A shell that has no light.
As the light flows down, the pain gets worse.
A shell that has collapsed and died with the wind.
Out of this hell, and back to the pearl sea where it belongs.
A shell that was once full of beauty, now darkened by the mirror of death
As the outside becomes an enemy, not a friend.
Drip, drip as the water that fills the shell is no more.

A Haiku

The trees are silently whispering.
Over the world, loving embrace.
She was guiding us home sweetly.

The Mirror of Truth

I'm broken into a thousand pieces.
I'm awoken as my heart has spoken.
For the first time, I am open to new possibilities.
I listen to the world, but somehow, it finds the
cracks in my mirror.
Putting me together again will be more
complicated than expected.
But light is always there even if I can't see it
some days, and my world has awoken.

Anxiety

The world is broken
Just like me falling into an on-the-go trail of
misery.
As I follow it, I am reminded of the pain
Stay focused. Don't let love slip away
I harness to protect. However, my body is
Neglect it becomes an enemy, one I wish to
forget. The ongoing trilogy of my life anxiety is
fighting me to the ground until the day I am
found.

Sword Fish

Sharp, shallow, silver
Air-breathing through fire
As one touch desires.
Each desired diamond that falls against us
Becomes us.
We are the swords of the seas.

My Grandad Holds the key to my heart

Grandad, if I could speak to you now, you would have influenced me to become more significant in everything I do. Your gentle nature, kind heart, and sense of humor all made me who I am today.
I remember all the good times we shared, and all the laughter was heard smiling upon us. You were more than my Grandad. You were my best friend too.
I love you so much, heaven has gained a beautiful angel, but I have lost my friend until we meet again love you forever in a day.

Lightning Source UK Ltd.
Milton Keynes UK
UKHW020006060922
408362UK00011B/2648

9 789395 223539